Pictures of a Childhood

Translated by

HILDEGARDE HANNUM

Farrar, Straus & Giroux

New York

ALICE MILLER

PICTURES

of a

CHILDHOOD

SIXTY-SIX WATERCOLORS
AND AN ESSAY

First edition, 1986

Library of Congress Cataloging-in-Publication Data
Miller, Alice.
Pictures of a childhood.
1. Miller, Alice. 2. Water-colorists—Germany (West)
—Biography. 3. Psychoanalysis and art. 4. Children
in art. I. Title.
ND1954.M55A2 1986 759.3 [B] 86–4454

CONTENTS

PREFACE

I should like to take this opportunity to thank Siegfried Unseld of Suhrkamp Verlag for his understanding, sympathy, and willingness to take on this book and to respect my ideas and wishes. Without his support, this volume could not have appeared in its present form. The interest, cooperation, and flexibility of Suhrkamp's Rolf Staudt aided considerably in solving, in a manner acceptable to both sides, the various problems that arose.

Sincere gratitude goes to Heide Coulon-Mersmann, who showed appreciation for my pictures and my ideas early on and participated with her own special brand of tact in the process of preparing them for publication.

The unforeseen and sympathetic understanding I found in the person of Renate Stendhal helped me come to the crucial decision that what I am expressing here can reach others. I thank her for our rewarding conversations concerning the text and for her careful reading of the manuscript.

I have not given titles to the watercolors included here because I did not want to restrict my readers' freedom of perception. As they view these pictures, they should be able to play with their associations and, influenced by their own history and way of seeing things, make discoveries for themselves.

Most of the watercolors have been reproduced in their original size. Numbers 8, 9, 21, 32, and 47 have been reduced; numbers 13, 29, 37, 45, and 53, enlarged. Numbers 5 (6.5 × 3.5 mm. in the original), 35, 44, 50, 51, 61, and 63 show enlarged details; numbers 59, 60, and 66, reduced details.

Pictures of a Childhood

CHILDHOOD AND CREATIVITY

These pages take as their point of departure the fourth chapter of my book *Thou Shalt Not Be Aware*, where I develop my ideas about creativity. There I state that traumatic experiences which occur in early childhood and which are later repressed often find expression in the creative works of painters and poets and that, furthermore, society is to a great degree unaware of this phenomenon, as are the artists themselves. I would not have noticed this connection either, had I not been confronted in the course of my own personal development with the way that childhood suffering can be repressed and subsequently expressed in art.

Questions about *my* childhood led me to questions about childhood in general, as well as to new insights into the subject.

Five years after I began to paint, I started writing my books, which never would have been possible without the inner liberation painting had given me. I continued to paint, using every possible medium—oil, oil pastel, gouache, and watercolor. This book reproduces a small sampling of the postcard-size watercolors I have done over the past two years.

Franz Kafka once noted in his diary that a writer must cling to his desk "by his teeth" in order to avoid the madness that would overtake him if he stopped writing. I suppose the same can be said of every creative activity that somehow permits us to come to grips with the demons of our past, to give form to the chaos within us and thereby master our anxiety.

I could have devoted myself exclusively to my writing, and it would have protected me from the fears that were sometimes awakened in me by the content of the pictures I painted. But I didn't want to let it go at that. I wanted to know what lay behind the dark curtain concealing my forgotten past, wanted to find out precisely what had happened during the period for which I had no memories. In twenty years of professional work with patients, I

3

observed the way they denied the traumas of their childhood, the way they idealized their parents and resisted the truth about their childhood with all their might. Gradually it became clear to me that genuine liberation was possible only for those patients who could bring themselves to face the truth and to experience their childhood pain. It would have been a betrayal of my self and my experience if I had now ignored the content to which my hand was giving form with the aid of colors or had attributed it simply to fantasy, without seriously searching for its roots in reality.

I didn't start painting until thirteen years ago, even though I had wanted to all my life, but without ever having been able to realize my wish. I had first to reach a high level of intellectual accomplishment and confront many anxieties before I could eventually enjoy the freedom of playing with colors in a totally spontaneous way. My playfulness, however, soon manifested its serious, even bitter side when the pictures that emerged before my eyes began to reveal an unfamiliar world—the world of my early childhood. What surprised me most was the fact that what they disclosed was entirely different from the nice version of that childhood I had been living with for decades.

To be sure, I had no memories at all of the first five years of my life, and even those of the following years were very sparse. Although this is an indication of strong repression—something that never occurs without good reason—it did not prevent me from clinging to the belief that my parents had provided me with loving care and had made every effort to give me everything I needed as a child. That was the way my mother would have described it had anyone asked her about my childhood. I had accepted her version all these years, in spite of the fact that my professional training had included two analyses and even though I should have been struck by the many similarities between my own history and the case histories of my patients.

Even in my second analysis, my mother appeared only as a somewhat oversolicitous woman with good intentions who had tried to do her best. It didn't fit in with the training or ethical attitudes of either of my therapists for them to acknowledge that her pedagogic

4

efforts had served *her* interests and the conventional ideas of her day while ruthlessly violating her child, whom she considered her property. Thus, in my second analysis, I still took pains to try to be understanding of my mother, to forgive her for her subtle psychological cruelty, which kept appearing in my dreams, and to ascribe its origins to my own failings. These "failings" consisted above all of the questions I asked and of my natural childhood needs for protection, closeness, understanding, and responsiveness. Since she was a brilliant pedagogue, she succeeded perfectly in crushing my true feelings and needs in such an imperceptible way that neither I nor anyone else realized what had happened. By an early age I had become a considerate, protective, understanding daughter who always gave priority to her mother's well-being and safety. It wasn't until many years later that I became aware I had a right to needs of my own.

Was this an unusual situation? By no means. Of course, not every mother channels all her ambition exclusively into bringing up her children—thank goodness; and sometimes there are fathers or older siblings who come to a child's rescue. But it was not at all unusual for a daughter who had no rights and who was under the thumb of her parents and brothers—the way my mother had been as a child—to seize the sole means of gaining power that society traditionally offered women as a "reward" for all the humiliation that had been heaped upon them. In the form of absolute control over the body and soul of her child an immense kingdom was granted her.

How could my mother be expected to turn it down? How could she be expected to question the assumptions of the pedagogical system that was still completely accepted at the time, now that it was finally enabling her to satisfy her long-suppressed needs for recognition, respect, and an audience and was fully legitimizing this rather perverse form of satisfaction, the raising of her child? Only the memory of a loving mother of her own— a *real* memory stored up in her body, not a merely fantasized one—would have proved stronger than the temptation to ward off her misery by means of the power she held over her child. My mother did not have a memory of this sort, for she herself had not received

5

love. She was raised on words—words about love, morality, and duty—and these were always available to her in place of the tenderness she was unable to feel.

My mother had her own time-honored beliefs of the kind people tended to have in those days, among them the view that every mother by definition "wanted only the best for her child"; these beliefs protected her from any doubts she might have had, and they never had to be called into question. Whatever she considered right was automatically and unquestionably right for her child and needed no justification as long as it was validated by society's conventions. Every mother had free access at that time to validation of this nature, for a child's spontaneous vitality was considered something dangerous that had to be subdued. And zealously subdued it was, at least in those days.

Is it any wonder, then, that those children who were robbed of their feelings forfeited their vitality and in the process lost the key to their past? Or that they remained silent about what they knew and that the opportunity to attest to what had been done to them never arose? The more I attempted to understand and justify my mother, the less I understood myself, for in order to succeed in that attempt I had to learn not to feel my own pain. Yet without being able to feel, I couldn't understand myself. No one can.

I was unable to alter my situation until I began to feel how much harm had been inflicted on me. This awareness became possible only when I finally stopped blaming myself for the resulting pain, stopped taking the plight of others more seriously than my own. It was this change of perspective that gradually brought such clarity to my feelings that I was at last able to find what I had long been searching for: the images and story of my past, which no one else could have shown me or told me about, since they were stored up solely inside me and I was the only one who knew them.

From my present point of view, I would say that I spent most of my life trying not to feel and, as a result, was well on the way toward destroying my self. Not until I started working with colors did a change occur. It is not rare for colors to awaken petrified feelings, but my past history played a specific role here: painting brought me in touch with the child

within me, who stopped drawing at a very early age and, in an attempt to rescue a part of her self from exploitation, "went underground." If my mother had displayed pictures of mine to her friends—the way she did my school notebooks—as evidence of her pedagogic talents, I might later have gone on to art school and gotten a diploma there. But no doubt I would have lost all desire to paint spontaneously as a means of expression, as my own language, once my mother took possession of what I created. She didn't have the chance to do so, because my need to paint disappeared deep within me in time to protect me from her pedagogical intervention and abuse. There it survived, and when I discovered it again after forty-five years and gave it free rein, I was amazed at the childlike curiosity and the intense delight in looking at things that came to light, still intact.

As I have indicated, however, the psychic terror imposed by my upbringing also made its appearance, the terror I had suffered under as a child but didn't remember in later years. Now it revealed itself to me more and more clearly.

The repressed feelings of my childhood—the fear, despair, and utter loneliness—emerged in my pictures, and at first I was all alone with the task of working these feelings through. For at that point I didn't know any painters with whom I would have been able to share my newfound knowledge of childhood, nor did I have any colleagues to whom I could have explained what was happening to me when I painted. I didn't want to be given psychoanalytic interpretations, didn't want to hear explanations offered in terms of Jungian symbols. I wanted only to let the child in me speak and paint long enough for me to understand her language. With time, this did come about, but not until a long search brought me to the person who could offer me the right kind of listening and support and not until I was gradually able to break free of constricting ideas that I had previously held to be self-evident, ideas that people in general hold to be self-evident.

I had to make the discovery, and experience it over and over again, that creativity has to do with a process which is not furthered by formal training. It was even true in my case that every attempt to learn a technique blocked my capacity to express myself. On the other

hand, the delight I took in the freedom I had gained was sufficient to impart an ability I had not previously possessed, an ability that emerged from play, experimentation, and wonder. All together, this added up to what is usually designated as experience, something that always came my way only indirectly and circuitously.

For example, when my travels took me to another city, I would occasionally take a life-drawing class. There would always be people in the class who had long since perfected their technique of drawing a nude according to all the academic rules and who were coming to class to keep in practice. I found this approach boring and felt great resistance to learning that way. Nevertheless, I sometimes attended such classes, for I appreciated both the way the others concentrated on what they were looking at and their attentive silence. I drew the model according to my mood, and if I wasn't in the mood to keep my eyes on the pose of the nude, I drew the faces of others who were drawing. As for painting techniques, I had to keep inventing or discovering them for myself, depending on how I felt at the moment or on what my present circumstances happened to be. The new techniques I developed at various times emerged from a strong urge to express myself as well as from the actual opportunities available to me.

For a long time I didn't have a studio, and I used an easel in a corner of one of my rooms for large oil paintings. Since it was important to me to work quickly and spontaneously instead of spending days on one picture, I began using painting pads. Being pressed for time, I developed the technique of applying broad, quick strokes with a soft, rather wide brush and an oil color much diluted with turpentine, letting my hand move at will. With a palette knife, I then superimposed on this wet color other, undiluted colors, which blended with the wet one and some of which ran down the paper. I used the knife to draw various shapes into this mixture, and sometimes the picture was completed in a few minutes. I left the pages out to dry for several days; then they disappeared into drawers because I had to make room for the next ones. Eventually I had hundreds of them, which I still take out and look at from time to time, for they serve as a kind of journal for that period. Later, when I

8

had my own studio, this technique lost its significance, since I now had other spatial and technical possibilities.

Little by little, I came to terms with the fact that, as far as my painting was concerned, I could never plan ahead or think about what I was going to do. If I did, the child in me rebelled and immediately became defiant. Only as I learned to follow her instead of forcing her to achieve did she share with me a new and precious knowledge about myself and my history that came to fascinate me more and more. It was difficult for me to comprehend that I had been ignoring this knowledge all my life.

Today it is clear to me in retrospect that my strong resistance to formal training, to thought and planning in the area of my painting, was highly significant, perhaps even saved my life. "If you only wanted to, you could get much better grades," one says to a child who is having difficulty in school. Don't children want to do well in school? Yes, of course they do, especially because they know a good report card can secure their parents' approval. But when they feel that the approval has nothing to do with *them* or with the love they are in need of, then it may come about that something inside refuses to produce good grades. They are unwilling to take part in a cover-up of a lack of love, and they use their bad grades to protest hypocrisy and to defend the truth, even if the latter should turn out to reveal their parents' ignorance and coldness.

Good grades would be a sign of psychic death, for they would silence the only language these children have access to.* A child's poor performance in school is a cry for help and can sometimes prove useful because it articulates suffering. Although this suffering can find expression only in the language of symptoms displayed by the child, at least it *is* being expressed.

A symptom like this will bring results, however, only if the parents are able to pay attention to it and thus reward the child's remaining trust and hope of finding help. In my

9

* *See* The Drama of the Gifted Child *(New York, 1983), pp. 9ff.*

own childhood, there was no room for such hope and trust. Therefore, I never caused anyone any trouble, I did well in school and apparently had no choice but to perform perfectly. When I was thirty-three, my mother told me that by the age of five months I no longer wet my diapers. At thirty-three, I did not yet realize it takes rigorous training to make a baby accomplish this feat. Since I had learned from the very beginning to regard cruelty as a method of child-rearing applied "for my own good," I didn't know there were any other possibilities. It took decades for me to recognize cruelty for what it is, to write about it and not let my newly gained awareness be undermined by the pressure of society. Society chooses to disregard the mistreatment of children, judging it to be altogether normal because it is so common. My present attitude is the end result of a long process in the course of which I have come to understand that the brunt of society's ignorance is borne by former children who, like me, were intimidated by their parents so forcefully, so skillfully, and above all at such an early age that even as adults they are still under the sway of this treatment and try to make excuses for it. It is therefore understandable that most people of my generation are never able to free themselves of the compulsion to defend and excuse their parents.

Probably I, too, would have remained trapped by this compulsion and, because it is so all-pervasive, would not even have recognized it as such, had I not come in contact with the child within me, who appeared so late in my life, wanting to tell me her secret.

She approached very hesitantly, speaking to me in an inarticulate way, but she took me by the hand and led me into territory I had been avoiding all my life because it frightened me. Yet I had to go there; I could not keep on turning my back, for it was my territory, my very own. It was the place I had attempted to forget so many years ago, the same place where I had abandoned the child I once was. There she had to stay, alone with her knowledge, waiting until someone would come at last to listen to her and believe her. Now I was standing at an open door, ill-prepared, filled with all an adult's fear of the darkness and menace of the past, but I could not bring myself to close the door and leave the child alone again until my death. Instead, I made a decision that was to change my life profoundly: to let the child

lead me, to put my trust in this nearly autistic being who had survived the isolation of decades.

How does one listen to an autistic child who won't speak? Every child speaks, even an autistic one, although not always with words. Our capacity to understand the language of mimicry, of gestures, of behavior depends on the degree to which we can hear the child within us, who endured so much suffering. Now it was up to me to take the first step myself—to listen to the child in me—and this meant exposing myself to all the pain once inflicted on her, which she had had to bear all alone, without witnesses, without words, without hope of ever being understood.

This child, who for years was hostage to her mother's ruinously mistaken ideas about child-rearing without another person ever coming to her defense, was exceedingly mistrustful. She had a remarkable sensitivity, which enabled her to detect even the tiniest hint of design, manipulation, or dishonesty. In this regard she was adamant and unwavering. If I didn't want to lose touch with her, I had to go along with her entirely. And I did. Looking back, I would say that the child in me, who wanted to paint, knew far better than I—with all my years of academic training—what she needed to express herself. Her total refusal to accept society's demands, to put up with its beliefs and conventions, was a sign of her strong urge to speak only in her own language, no matter how awkward and strange.

This urge of hers has had an inescapable influence on my style, which I would describe as one of improvisation. I must continually search for and find what is new, feel my way, experiment. I can never work slowly or stay with what I'm doing till it's completed, nor can I take advantage of what is already familiar to me. I have to give myself over to the undertaking of the moment, for it seems to follow its own laws and to elude any supervision or censorship. As soon as I attempt to give it direction, to reflect, to work more slowly, my progress is impeded; the end result may look technically proficient, but it bores me, probably because it does not speak the language of the unconscious, which, by its very nature, becomes silent in the face of my knowledge and my skills.

11

In a certain sense, then, I can only improvise. There was a time, twelve years ago, when I sometimes wanted to paint pictures of what I had dreamed about the night before, but I never succeeded. My painting is always a matter of the moment. Whenever I have something specific in mind, even if it has to do with my own dreams, i.e., with my unconscious, I develop a block. As I paint, I can at most dream new dreams but not portray a past one. Nor can I have any intention of executing a canvas in a certain way, without soon changing my plan completely. The same thing happens when I try to copy from painters I consider important. I begin, and after a few minutes an entirely different picture emerges, one that has little to do with the way I started out.

My inability to copy applies most of all to paintings. I have had more success in copying drawings: faces by Leonardo da Vinci and Picasso, drawings by Rembrandt—I have copied over and over again faces he drew. In addition to studies of nudes done in art classes and furtive sketches of faces made in restaurants and hotels, copying provided my training in drawing. But these were always quick sketches and were unmistakably *my* drawings and not accurate reproductions. When I worked with colors, however, I was unable to complete a copy of even the simplest picture by Picasso or Nolde. Picasso, in particular, inspired me to express myself freely and to respond to his stimulus with my unconscious. The moment I resolved to remain true to the original, I felt as though I were caught in a vise.

Most teachers would say, "You must overcome this block; you can't learn until you have mastered your feelings of resistance." I never was able to make any use of advice like this, for my experience showed me that I definitely could learn from my resistance, whereas if I overcame it, something important was lost in the process: freedom, delight, and ultimately energy as well. Gradually I learned from this experience. If I was making a copy of a Nolde watercolor, for example, which I enjoyed doing in the beginning, I used his work only to get started. It was as though I were searching for encouragement from an accomplice, not for a master of the craft. Once Nolde had helped me to feel freer, I forgot about the picture I had started working from.

I do not mean to say that copying always destroys creativity. Even great painters have made copies, and it is said that students must first master their tools and learn the various techniques before they can begin a work. I have often heard this, and although it may be true for many, it is not true for me. It took me a long time to find this out and to resist the established body of knowledge that so tenaciously held me back from experimenting with colors. Otherwise, I never would have dared to try something that is generally considered wrong yet is right for me.

Technical mastery and skill may be helpful to many, but they are not necessarily so. They can even become a prison for those who are afraid to express themselves, for such artists may cling to their technical proficiency and hide behind it. I have seen drawings that are true to nature down to the last detail, with scarcely a single flaw, yet they seem lifeless because the person who drew them is not sensed there at all. Any picture, even an abstract one, strikes me as lifeless if I am not given any impression of the person who painted it. It may be that the picture is simply expressing the temporary lifelessness of the painter, and to that extent it, too, is making a statement.

Who knows how many creative urges are destroyed by the art academies? There, students must prove themselves by achieving and are not allowed to follow their inclinations. It requires a great deal of independence and emotional security to follow one's own impulses when confronted with an emphasis on acquired skills and the current style. Even later, after one completes school, ability can be a prison. There have been artists who could no longer bear the confines of their own perfection, who burst free of their bonds and then discovered a whole new world of expression.

Two such artists were Turner and Goya, both acclaimed as great masters of the style of their day. They were later scorned for going ways that were unfamiliar to others but essential for themselves. Most people hold fast to what they know, adhere to traditional views, and feel threatened by anything they cannot classify. By showing contempt for something new, they regain their peace of mind and avoid having to come to terms with it.

13

Cézanne was laughed at by his early critics, and after an unsuccessful exhibition one of them wrote mockingly that Cézanne was now carrying his pictures back home like Jesus the cross.

Examples such as these often occurred to me when I heard arguments for the necessity of formal training. How sure Cézanne's critic was that he was right, I thought, simply because he was so knowledgeable about the taste of his times. What he had learned provided him with a feeling of security, reinforced, as it were, by blinders. For there was nothing he could ever have learned about Cézanne's world, since this world had not existed before. Only Cézanne himself could discover it, and he had no choice but to explore it when faced with the mockery and arrogance of the so-called experts. He had to be born into a world that wasn't ready for him, that rejected him because it felt called into question by him. Yet he had to question that world, he had to leave the comforting womb of convention in order to be born as Cézanne and not as an imitator of one living painter or another.

I once wrote, drawing on the examples of Turner and Goya, that art has more to do with courage, more with daring, than with ability. Today, however, I must modify this statement, for the word "courage" denotes a virtue and therefore has a suspicious ring to me. Perhaps it is more accurate to say that art has to do with *need* and not with accomplishment, for artists often have no choice but to risk being ostracized, scorned, and rejected for articulating their own truth. At stake is the survival of one's authentic self, and in this regard there is no alternative but to try to survive. Many artists know there is no other route for them to take.

Similarly, the unborn baby emerging from the womb has only one route by which to reach the light of day. A baby sometimes has to take into the bargain that its mother hates it for the pain its movements cause her if she holds back and impedes its progress, thereby threatening its life. The baby must continue on its way undeterred if it is not to die. Sometimes I feel something of its distress when I am painting, although I had never thought in these terms before; this is an analogy that has entered my mind for the first time now as I write. The effort to express oneself beyond the point of everything learned previously,

14

the danger of being rejected, ignorance as to why or whither, and the total concentration on what one is doing, on the moment, along with the urgency of the task—all this applies to the situation not only of the artist but also of the unborn child in its struggle for life.

The creation of a work of art has often been compared to giving birth, the artist identifying with the mother by bringing a "child," the work of art, into the world. In Kafka's diaries there is a famous passage in this vein about writing his short story "The Judgment." Yet, as I envision the creative process, I do not identify with the mother giving birth but with the child struggling to be born. This holds true for my writing as well as my painting. I am sometimes asked where I found the courage to write *Thou Shalt Not Be Aware*. There, too, I felt that I had no choice. After I discovered how hostile society is toward the child and then was unable to find others who shared my view, I simply had to keep on striving to understand why I was so alone and to find my place in the world.

I was in the position of someone who must keep on swimming in order to reach the shore; she would scarcely be called courageous because she doesn't stop swimming. If she did, it would mean her death, just as not to have written *Thou Shalt Not Be Aware* would have meant destroying what I had found, i.e., killing a large part of myself. This is probably valid for everyone who paints or writes out of an inner necessity.

We are often imprisoned in the cage of our own abilities and routines, which provides us with a sense of security. We are afraid to break free; yet we must gasp for air and keep seeking our way, probably over and over again, if we do not want to be smothered in the womb of what is familiar and well known to us, but rather to be born along with our new work.

I see the moment of creation as linked to being under this kind of pressure, although of course the pressure is never so intense as it is for the baby in the process of being born. When we consider how long birth takes, how long the yet unborn child is subjected to fear, uncertainty, and desperation if the birth is a difficult one, then nothing that we undergo in later life can match it in intensity. For the unborn do not yet have any alternatives open to

15

them, nor do they possess an intellect to help them understand what is happening and thus come to terms with it. They are capable only of feeling. Today we know for a fact that they do feel, not only from the reports of adults who have relived the pain of being born but also from the monitoring of intrauterine life by means of sophisticated electronic equipment.

I suspect that while I was painting some of my pictures I was experiencing something of my early distress connected with the struggle to become free. Sometimes when I had finished, I had the happy feeling of having succeeded, not in terms of accomplishment but in terms of delight: I was able to satisfy my need to be playful, to express myself, to take sensual delight in colors—and I had survived.

Since then I have discovered that when repression has given way to a new awareness of the traumatic experiences of my childhood, this process has not interfered with my creativity but, on the contrary, has deepened and enriched it. I do not find this surprising, for in my eyes creativity is synonymous with the freedom to be playful, which is restricted, not encouraged, by repression.*

When I am painting, I do not need to convince anyone that two and two make four, not five; I can even play with the idea that two and two do make five, since I am not bound by any rules while painting. This gives me a feeling of freedom that is not comparable to anything else I know, a feeling that—in view of my past—I need and enjoy. I know there are various theories of color, but I do not adhere to any of them, for no one can tell me what to do, and this is exactly what releases my spontaneity. Which color I choose, what amount of it I use, where I place it, which implement I take to apply it, which shapes occur to me at the moment—all is simply a matter of "chance," which is what I call my unconscious, and of my delight at being able to leave it to chance. I don't know if others feel the same way, but it means a great deal to me to have this margin of freedom, because as a child I never had it, except perhaps for the times when I went ice-skating.

16

* See Thou Shalt Not Be Aware *(New York, 1984), pp. 244–45.*

Only when I make room for the voice of the child within me do I feel myself to be truly genuine and creative. I use every means now at my disposal—in my painting, the experience I have gained through developing my own personal technique; in my writing, the experience I have gained through the practice of psychotherapy—to help this child to find the appropriate way of expressing herself and to be understood. I give her what she never had before: the supportive presence of an adult who takes seriously what she has to say instead of dominating her with platitudes and destroying her creativity.

There is no longer any doubt in my mind that as I am doing my spontaneous painting, the repressed knowledge of events that took place long ago is breaking through. My quickly executed watercolors are like snapshots taken at a certain time in my life and in my "technical progress." At another moment the same past event takes an entirely different form. In addition, my willingness to admit to the suffering of my childhood and not ward it off is less pronounced at some times than at others, and my unconscious cannot always speak with the same degree of clarity. I am fascinated by this ongoing dialogue between me as a grown woman and the little child in me, a dialogue which was initiated as a result of my beginning to experiment with colors and which then continued thanks to the aid of my writing. I have been able to give the silent child of long ago the right to her own language and her own story. Now she refuses to be dissuaded from remembering, from perceiving what really happened and reporting it with ever growing clarity.

Some of my pictures convey her reports. When the adult part of me tries to alert and sensitize society to the suffering of childhood, I tend to use words and write about it, but I do not exclude the possibility that pictures can also provide information, the way written words about childhood do, and that they, too, can help to break down the walls of ignorance. By ignorance I mean the lack of awareness with which human beings respond to their children and from the very first moment—often altogether unnecessarily—submit them to martyr-

dom, solely because they do not know that children feel and do not realize the repercussions these feelings have in later life.

It wasn't until I wrote my books that I found out just how hostile society is toward children and how it ignores this fact. In *For Your Own Good* I described this tendency in its most extreme manifestations in my attempt to comprehend why so many helpless human beings had been tortured, gassed, and burned in Nazi Germany. Not until I came to the conclusion that the perpetrators were driven again and again by a compulsion to murder their prisoners in place of the children who they themselves had once been, and whose souls had not been permitted to live, did the tragic logic of this absurd behavior reveal itself. More recently I have come to realize that hostility toward children is to be found in countless forms, not only in the death camps but throughout all levels of society and in every intellectual discipline, even in most schools of therapy. As I began to shift from writing *about* children to lending children themselves a voice, I encountered the hostility directly. Prominent periodicals, for instance, eager for me to submit an article, lost all interest when I informed them I would write about family violence.* At first I couldn't understand why, and it was hard for me to grasp, for I found the voice of the child speaking in my books—whether in the words of Kafka or Flaubert or in the accounts of patients—to be highly convincing. Only later did I understand that it is the very persuasiveness of the child's words that antagonizes adults and evokes their negative attitude.

Those who take a stand in today's world on behalf of workers, women, or even mistreated animals will find a group to represent them, but someone who becomes a strong advocate for the child and opposes the lies society has tolerated in the guise of child-rearing practices

18

* *The German magazine* Brigitte *proved to be an exception. In a special issue (October 1982) entitled "Frauen und Bücher" [Women and Books], they published my article "Die Töchter schweigen nicht mehr" [Daughters Are Breaking Their Silence] (see* Thou Shalt Not Be Aware, *pp. 319–26).*

will stand alone. This situation is difficult to understand, especially when we consider that we were once all children ourselves. I can explain it only by suggesting that unequivocal advocacy of the child represents a threat to most adults. For when it becomes possible for children to speak out and confront us with their experiences, which were once ours as well, we become painfully aware of the loss of our own powers of perception, our sensibilities, feelings, and memories. Only if the child is forced to be silent are we able to deny our pain, and we can again believe what we were told as children: that it was necessary, valuable, and right for us to make the emotional sacrifices demanded of us in the name of traditional child-rearing. As a consequence of the adult's arrogant attitude toward the child's feelings, the child is trained to be accommodating, but his or her true voice is silenced. Another arrogant and blind adult is the result.

Is it not senseless, then, to let children speak, to help them to become articulate in an arrogant adult world as long as there is so little hope of their being listened to by adults and when the danger exists that their authentic voice will be silenced as soon as it is heard? I do not believe it is senseless; it is essential to let their voices, the voices of those who have been afflicted by silence, speak if we hope to prevent the total disappearance of the springs of knowledge and creativity concealed in every childhood. In this regard, the published reports by former victims of child abuse will be particularly beneficial in exposing the distortion of the truth so widespread in many areas of our life.

An example of this distortion, with which I am well acquainted, may be found in the theory of infantile sexuality; it demonstrates strikingly the influence society's hostility toward children has exerted even within an intellectual discipline. The idea that children feel sexual desire for their parents and "must learn to renounce this desire" gained a firm foothold in psychoanalytic theory in spite of its patent absurdity and has been able to survive for nearly a century because adults' sexual abuse of children has remained such a well-kept secret.*

19

* See Florence Rush, The Best Kept Secret (Englewood Cliffs, 1980).

That this idea is a projection never occurred to the profession, since psychoanalysts themselves grew up believing, in keeping with the pedagogical principles of earlier generations, that children come into the world with wicked drives, which we, good adults that we are, must bring under control by teaching them what is right. Our grandparents were not aware that there was a great deal to be learned from children about the hypocrisy of adult standards and about the cruelty of the pedagogical methods we employed; today we are just beginning to suspect it. This is why psychoanalysts, overlooking the child's actual needs, have for decades been able to take it for granted that children invent incriminating stories about their innocent parents, whom they desire sexually or want to murder, not because of having been tormented and abused but because they, the children, are prevented from satisfying their "incestuous wishes."

Such a crass projection of the adult's own sexual perversion onto the child and the accompanying casting of blame onto the victim could be sanctioned by a learned profession only as long as the victims felt intimidated by the power of the perpetrators and remained silent as a result. Now that many of them are finding their voice and telling about what was done to them, others with similar experiences are also being encouraged to face the truth and in so doing to correct the psychoanalytic profession's false assertions and its prejudices based on pedagogical assumptions.*

It is customary for us to think in abstract, disconnected categories and to divide intellectual activities into distinct abstract fields such as literature, art, science, politics, education, etc., combining these concepts with images arising from our own experiences. We often think in a vague and diffuse way of the poet or artist as withdrawing from the world

20

* *See* Thou Shalt Not Be Aware, *Afterword to the American Edition, pp. 309–18.*

of external events into an "inner world"; we associate the politician with an overcrowded appointment calendar, a travel schedule of enormous proportions, and constant shuttling between conference tables. We tend to designate as political the kind of conference at which putting out fires with water buckets is discussed, with the proviso that no one inquire into the cause of the fires.

Such inquiries are reserved for mavericks, who for one reason or another have not lost the ability to ask questions. Sometimes these nonconformists hit quite unexpectedly upon discoveries with far-reaching political implications which actually have the potential to change society and slow the escalation of violence, perhaps eventually bringing it to a complete halt. In order to prevent future wars, we do not need new weapons and more conference tables; what is needed is the widest possible dissemination of information about the breeding grounds of violence, about the places where it is nurtured.

One of the lonely innovators and valuable informants of our time is the French obstetrician and artist Frédérick Leboyer.* Untold millions of people who have been in attendance when babies are born (doctors, midwives, nurses, family members) have taken it for granted that the newborn will cry out of physical necessity. Amazingly enough, they did not perceive the obvious fact that the face distorted with pain and the little creature's cries were nothing other than the expression of psychic distress.

Leboyer was the first to ask the long-overdue question of how babies must *feel* when, after an often difficult struggle for survival, they are lifted up by their feet and submitted to brutal routine procedures instead of being comforted. He *proved* that if the newborn are treated with great care, in keeping with their psychic state, they are able to *smile* just minutes after being born and do not cry. Since Leboyer's discovery, many mothers have had the opportunity to find this out for themselves with their own children. As a result,

21

* *See* Birth without Violence *(New York, 1975)*.

delivery procedures have been modified to some extent, although there continues to be great resistance on the part of those professionals who refuse to abandon what they learned many years ago.*

For some time I regarded Leboyer's work as addressing only the problems of delivery methods. Then, a few years ago, I was astounded when the *political* ramifications of his discovery caught my attention. Not until I found out that the physical and psychological cruelty inherent in our child-rearing methods unleashes an impotent rage of extreme intensity in the child did I grasp that the roots of later violence are concealed in these methods. Since "disciplined" children are forbidden to express their rage, they must completely repress and deny their plight. This realization led me to the question of what happens to the intense feelings of a very young child who is treated cruelly. I asked myself whether the early repression of pain and rage isn't even more dangerous for the victims and for society than the repression that occurs later, since the former is more inaccessible to the conscious self. Are the consequences of such repression ever associated with its causes, and can they ever be understood? As I asked these questions I again happened upon the works of Leboyer, and this time I understood: it actually is in the way the newborn have been treated, until very recently, during the first minutes of life that society makes the first of its many contributions toward instilling destructive and/or self-destructive tendencies in the tiny being who has just entered the world.

My assumption was confirmed by the reports I read of patients undergoing primal therapy. They prove to me that a person's traumatic experiences have been stored up in the body from the very beginning and that the repressed memories can be made accessible as soon as the right conditions are created. These patients reveal information which appar-

22

* Along with resisting this new knowledge, obstetricians have also come to covet their free time and are increasingly trying to convince expectant mothers of the "advantages" of induced labor.

ently has not yet been discovered by most of the "experts" but which nevertheless will alter fundamentally our conception of the human being, probably even in the near future.

Unfortunately, successful primal therapy is still a rarity today because it is so often encumbered with pedagogical prejudices. As long as therapists continue to resist the signs of radical change in treatment methods instead of encouraging them, destructive reaction formations will persist. I consider the so-called mixed therapeutic approaches, such as transactional analysis and "primal therapy," with their pedagogically slanted techniques, to be particularly harmful.

Yet quite apart from the practical considerations of how many people have the opportunity today to seek out effective primal therapy or to give birth without violence, I am interested in the more general question of what consequences the latest discoveries about early childhood will have for the consciousness of humankind.

Two important aspects of this question have already been answered for me: (1) as primal-therapy patients begin to discover their own truth, for the first time in human history victims of child abuse are beginning to articulate their suffering; (2) by showing us on film a smiling baby only a few minutes old, Leboyer and others have refuted empirically a number of old fictions concerning the "destructive drives" we are supposed to bring into the world with us.

The contrast between the pain-racked and the smiling faces of the newborn is sufficient to make me realize with horror what we have done to our children out of insensitivity and lack of awareness. Yet this contrast is also all it takes to awaken in me the hope that someday in the future, as soon as we have integrated the new knowledge, we will be able to do away with the unwanted seeds of violence. It is here that I see the realization of the social and political implications of our new knowledge taking place once it has become available to the general public.

23

Furthermore, now that new therapeutic approaches which help patients uncover the

traumas of their childhood have restored speech to those who were threatened and forced to be silent as children, these newly awakened voices will henceforth play a role in enlightening and humanizing society. No longer will they speak solely in the symbolic, i.e, disguised, forms of literature and art, for now they can communicate directly, with full consciousness and full responsibility.

The following passage, quoted from an unpublished article* by Hans R. Böttcher, professor of psychology in Jena, East Germany, illustrates what I mean here and also shows why it is not easy to verify my theses statistically, even if they are correct. The case he cites describes the specific type of traumatization that occurs in a situation where there is no understanding witness to come to the aid of a child who is treated cruelly, for those who inflicted the cruelty did not understand at the time, and often still cannot understand today, what they did to harm the child. Böttcher writes:

In conclusion I should like to report my own experience as a psychologist with clinical psychologists and doctors. They are stirred up by books they read, which leads them either to resistance on a theoretical level or to a flood of terrible personal memories. In the latter case, some of them try to determine whether their subjectively crucial impressions of childhood and of their parents are valid or not by talking about their recollections with the parents themselves. As a rule, the result is negative. It is not only that the younger generation, raised not to be aware, has clung overly long to a prettified image of their childhood and their parents; the parents, too, are much more likely to remember the good they intended and actually did than the harm they caused. An older colleague of mine, who as a youth succeeded in distancing himself from his parents and struggled to gain critical awareness of his own developmental needs, was in a teaching analysis for some time before becoming a psychotherapist himself. Because he wanted to get to the root of a traumatic childhood experience, he tried to talk to his mother—an affable, rather cool,

* *Submitted to the journal* Zeitschrift für Jugendpsychologie.

rather reserved woman—about it. He brought up the subject repeatedly—when she was around fifty, again when she was sixty, then seventy and eighty—but in vain: she couldn't remember it.

When he was not yet seven, a schoolmate had talked him into going to fly their kites instead of doing their homework and then into telling a twofold lie: at home he said, "We weren't given any homework"; at school, "I forgot to bring it." Since the teacher insisted that the assignment be made up and then asked for an explanation signed by a parent, the boy grew frightened and distressed, sinking deeper and deeper into the dilemma posed by the lies he had told. He threw the teacher's letter to his parents over a fence, intending it to land in the brook on the other side, but actually it fell into a bush of stinging nettle. After a few days, the teacher spoke directly with the mother. When the boy's deeds had been exposed, his mother scolded him severely, pushed him into the nettles, and spanked him with her slipper. Then she and the wrongdoer's younger sister lay down on the sofa "to die of disappointment," as she said, over her son who had turned out so badly. He implored her to let him die too, but his entreaties were ignored. The blows he had been dreading from his father that evening came as a relief in comparison. In addition, this gifted child, who did so well in school, was confined to the house for several weeks, and every day after doing his homework he had to fill the back of a large sheet of paper with the words "I must not lie to my parents or teachers," which took him hours. To repeat: the psychologist remembered this incident vividly for the rest of his life, especially when he reacted depressively to abandonment or social setbacks that were "his own fault." But his mother, who by now had very good judgment when it came to human relations, remembered nothing of it. Was this simply because she was abreacting her feelings of disappointment, because she believed she had behaved with pedagogical correctness, or because she had later repressed an episode that was painful to her? Miller would add the supposition that the mother herself had probably been subjected to similar harshness as a child. But she remembered little of that, either. She was "a latecomer in the family, favored by both parents and four brothers, then at fourteen became an orphan and had

25

to be taken in by friends." How much can parents know, after all, of the "primal pain" (Janov) of their own children?

It isn't hard to imagine how little progress we would make if, in the interests of establishing statistically based judgments, we were to have children, their parents, and their grandparents fill out inevitably superficial questionnaires about what had happened to them in their lives and then expect to measure the correctness of our hypotheses by the extent to which their responses were in agreement.

Again and again in conversations with therapists, some of whom even subscribe to the latest theories, I notice a lack of imagination and understanding on an emotional level for the true situation of the mistreated child, the same lack that Böttcher presents so impressively in the foregoing description of a mother. Many of them simply do not seem to realize that the very phrase "It was your own fault," which sounds so fine and moralistic, has the potential to block at a single stroke a powerful process of liberation that would otherwise be possible for the patient. Instead of uncovering their feelings—step by step, with the therapist's help— by recounting the story of their mistreatment in order to free themselves of its continuing consequences, patients must use up their remaining energies to keep in check their so-called destructive tendencies (and therefore their vitality as well!), without realizing that their repressed rage is in fact a perfectly normal reaction to the wrongs they suffered. In legal language, many of these wrongs would without any question qualify as crimes if they had been committed against adults instead of children. Most therapists I know react with astonishing indifference to such deeds if perpetrated against their patients in childhood.

But the breakthrough to awareness has already taken place. Daily media reports of child abuse are contributing increasingly to bringing to light the previously concealed breeding grounds of violence located within the family.* Simultaneously, individual children who had

* See Louise Armstrong, Kiss Daddy Goodnight *(New York, 1978)*.

the good fortune to grow up without being subjected to hypocrisy and cruelty are providing humanity with an intimation of the way human beings could be as a matter of course: critical, perceptive, empathic, and without any need to wound others or themselves.

All of this has not only personal consequences but far-reaching social ones,* for then the people in one's life, such as living-partners, subordinates, and, most of all, one's own children, would not have to suffer for the sins of others. Those who need not fear the truth about themselves, who have not felt (or no longer feel) compelled to protect their parents by means of self-deception, will not ward off the truth about others or deny others' suffering. If they were not lied to as children, they will have no trouble recognizing every form of lie or hypocrisy and will not countenance being used to perpetuate lies. Therefore, unlike the Eichmanns of yesterday and today, they will never be capable of relegating responsibility for their actions to abstract numbers and computers. Reason, combined with feelings, images, and memories that do not have to be split off, will protect them from that kind of blindness.

If battered children such as Hitler, Eichmann, Höss, etc., have been able to destroy human life on the monumental scale history clearly indicates they did, then it is only logical to ask how beneficial an influence children who are not battered or abused can have on the world when they grow up. Such children will, with all certainty, have no cause to destroy themselves with drugs, alcohol, and cigarettes or to let society cheat them out of their soul. In any case, they will not have to wait forty-five years, as I did, to pick up the paintbrush that might tell them the truth about their history. For they will not need to fear that truth.

27

* See Thou Shalt Not Be Aware, *pp. 199–200.*

Sixty-six Watercolors:

PICTURES OF A CHILDHOOD

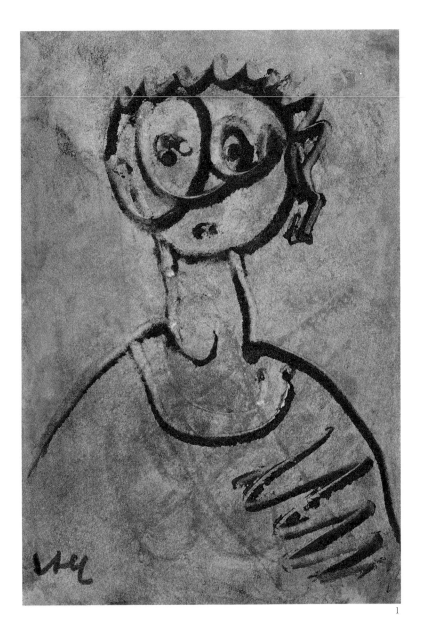

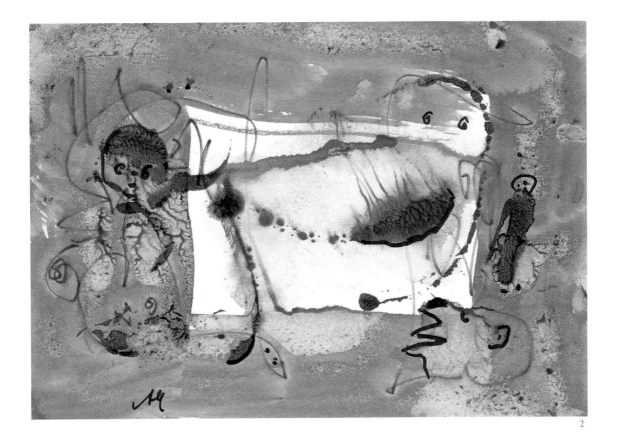

2

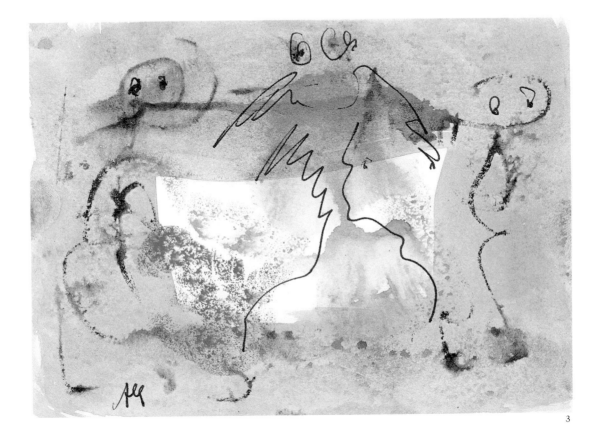

3

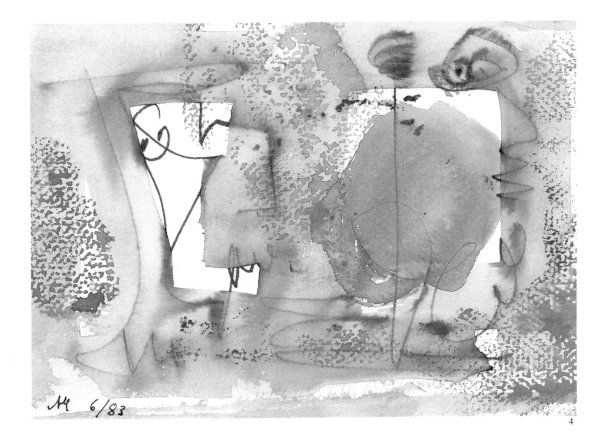

MM 6/83

4

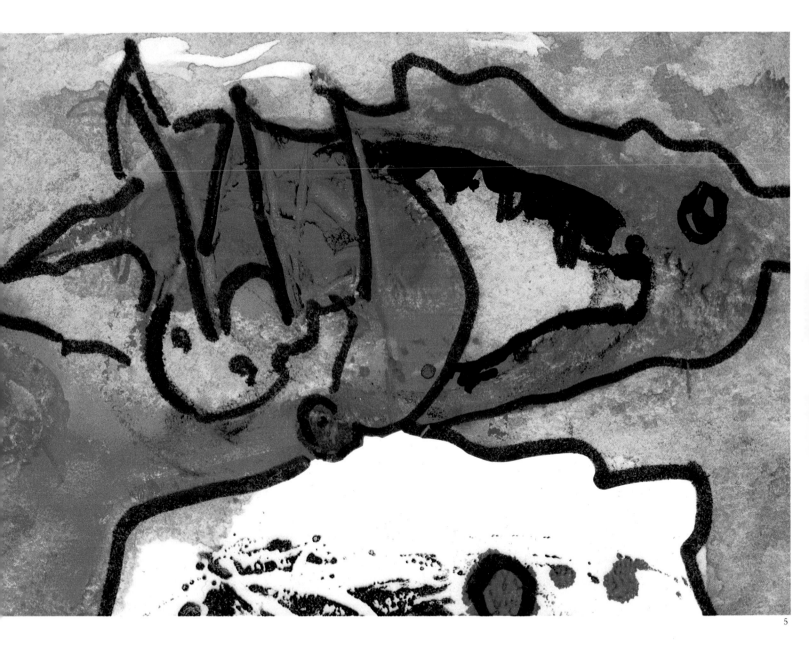

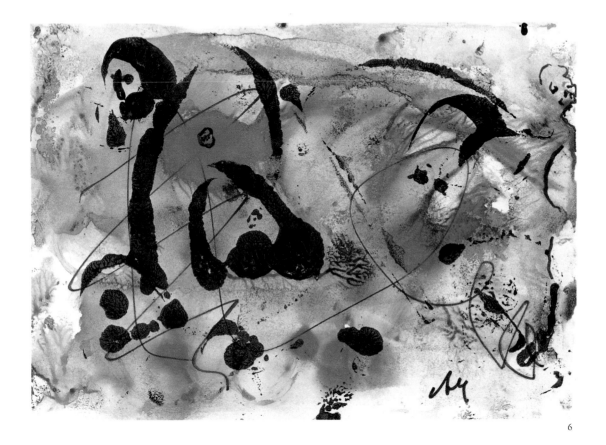

6

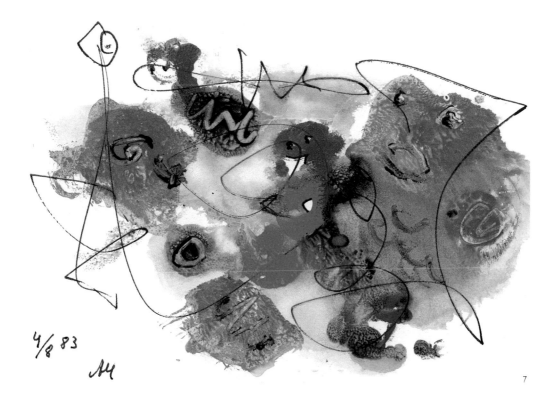

4/8 83

AH

7

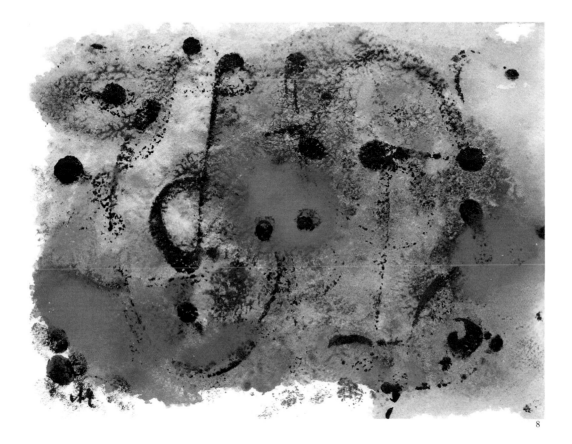

8

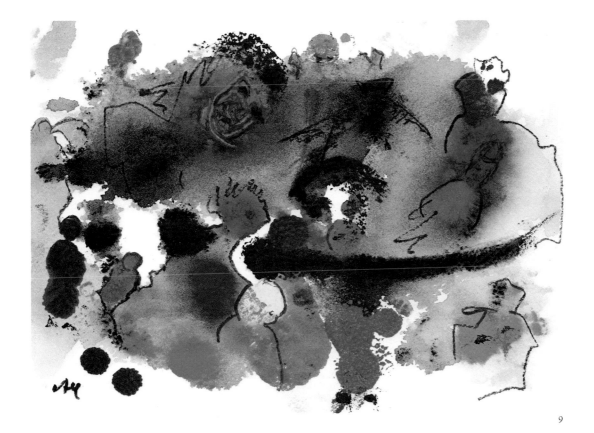

9

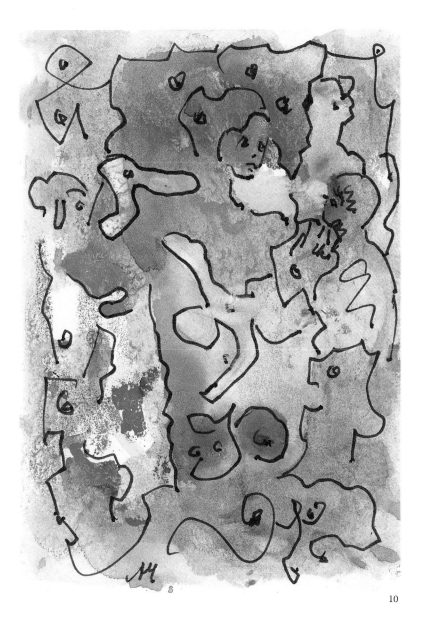

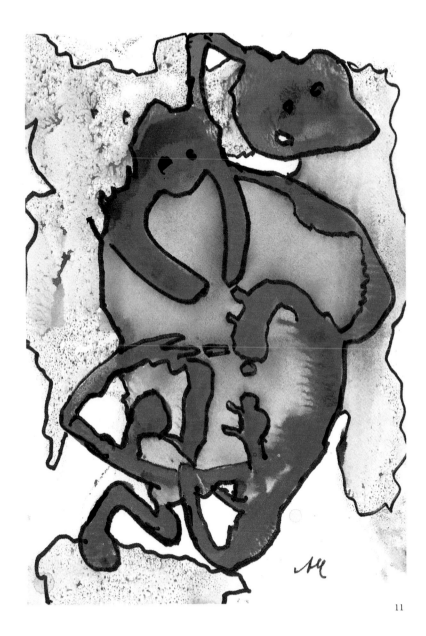

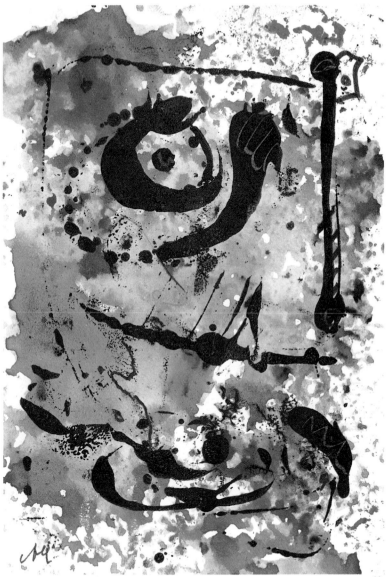

12

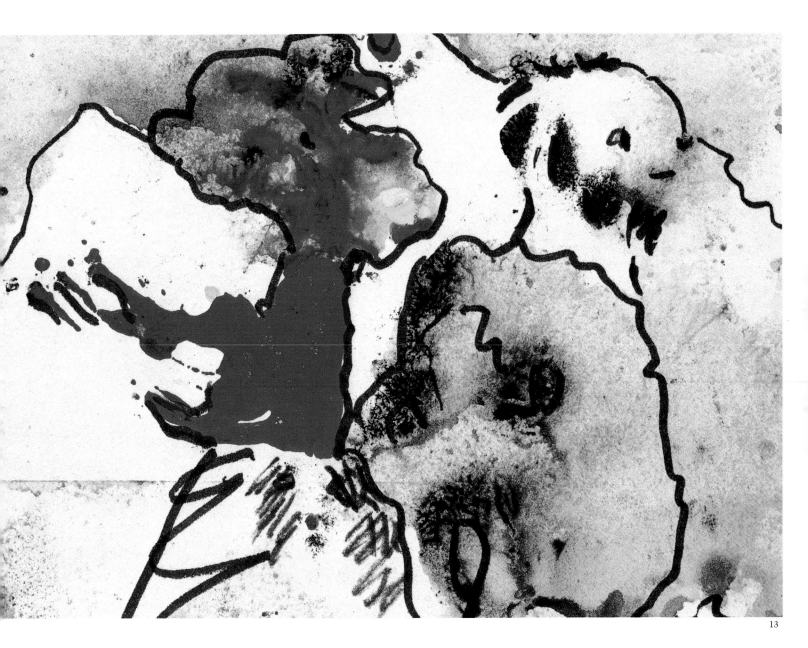

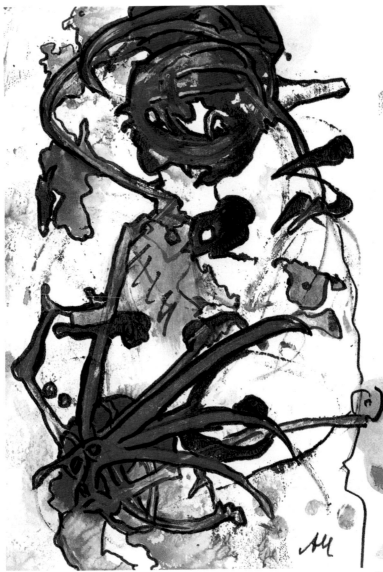

14

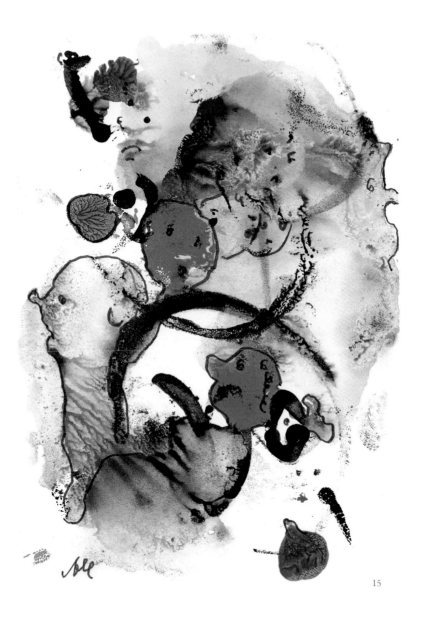

15

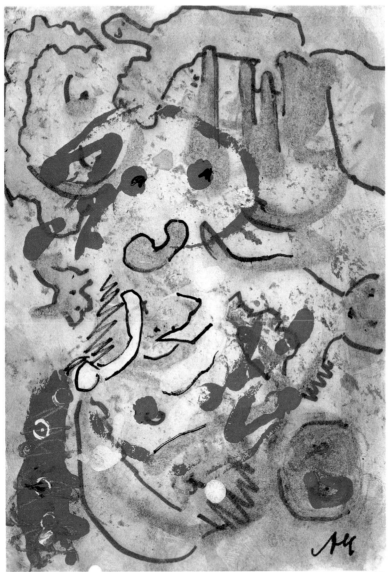

16

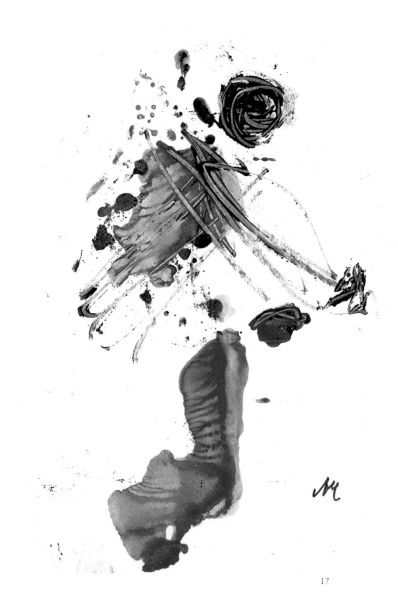

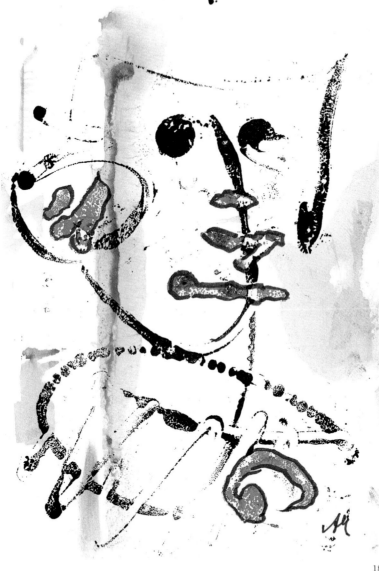

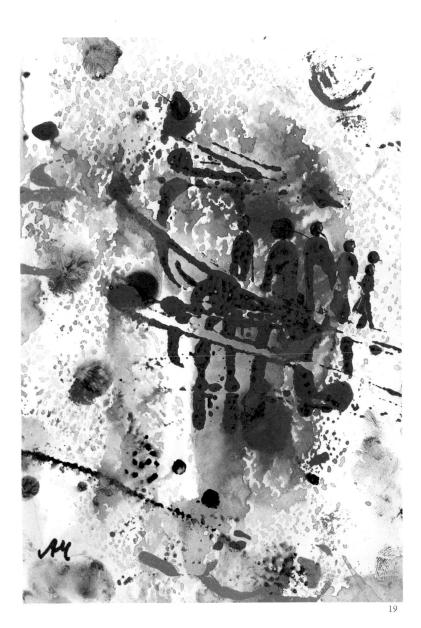

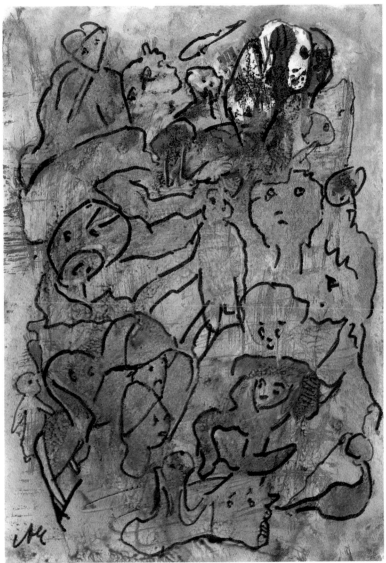

20

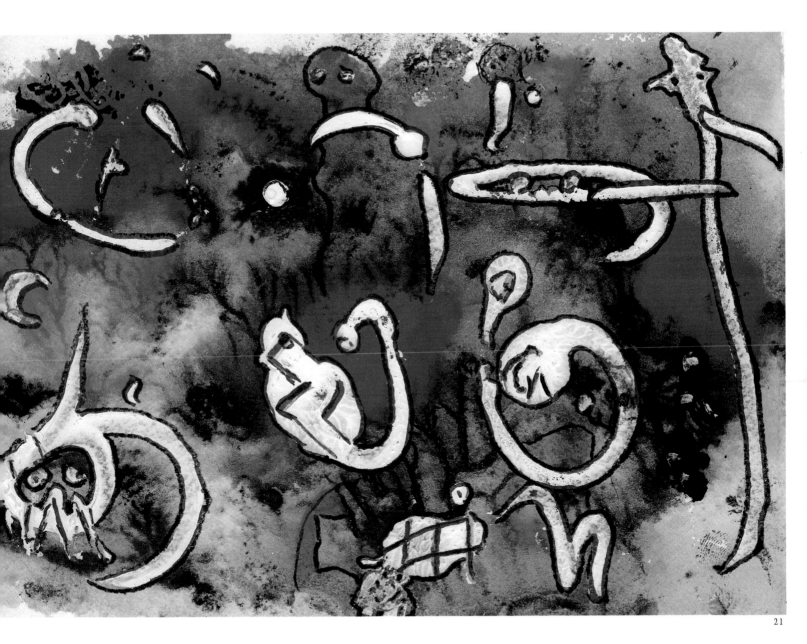

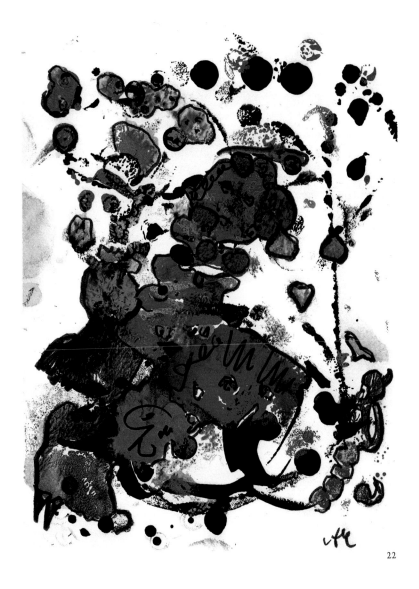

22

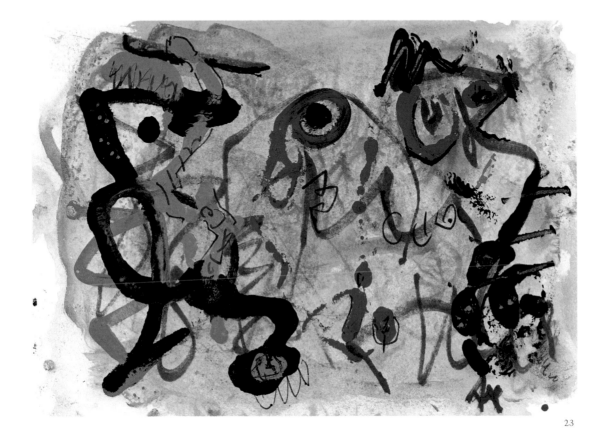

23

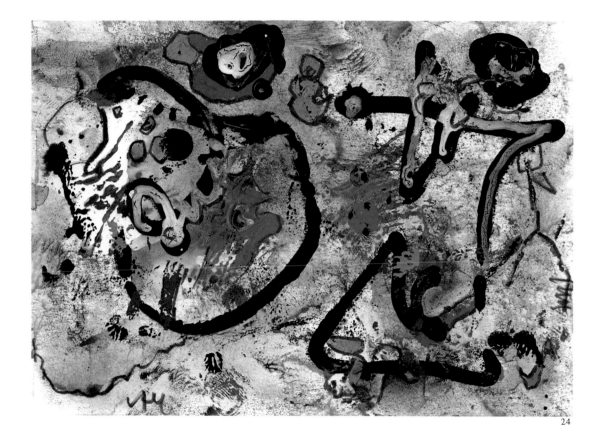

24

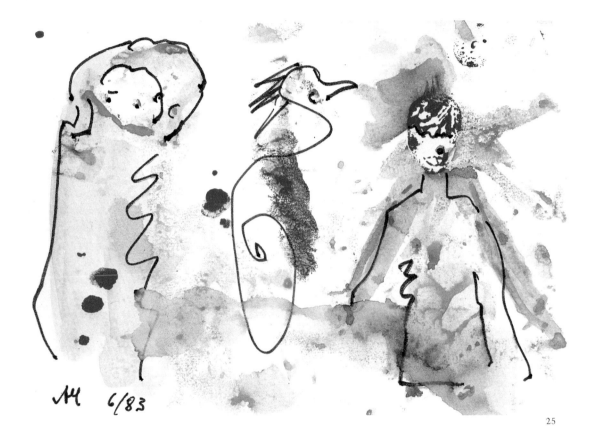

M 6/83

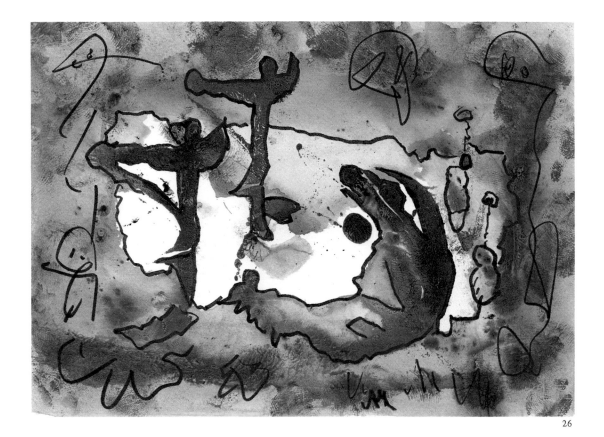

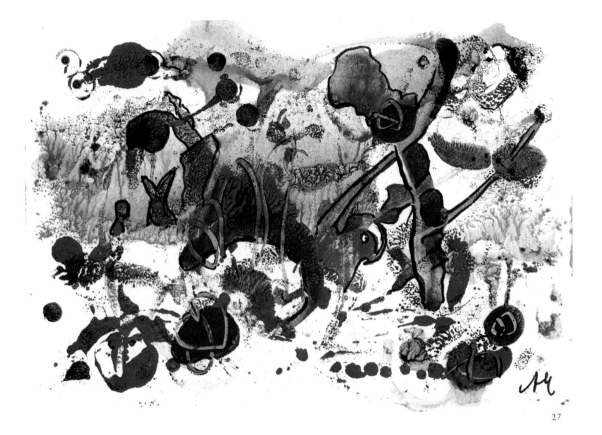

27

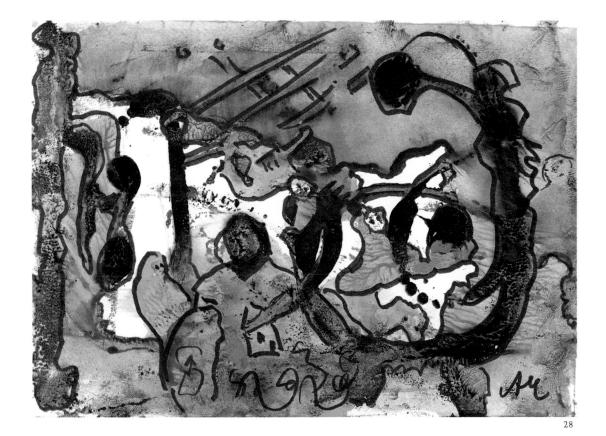

28

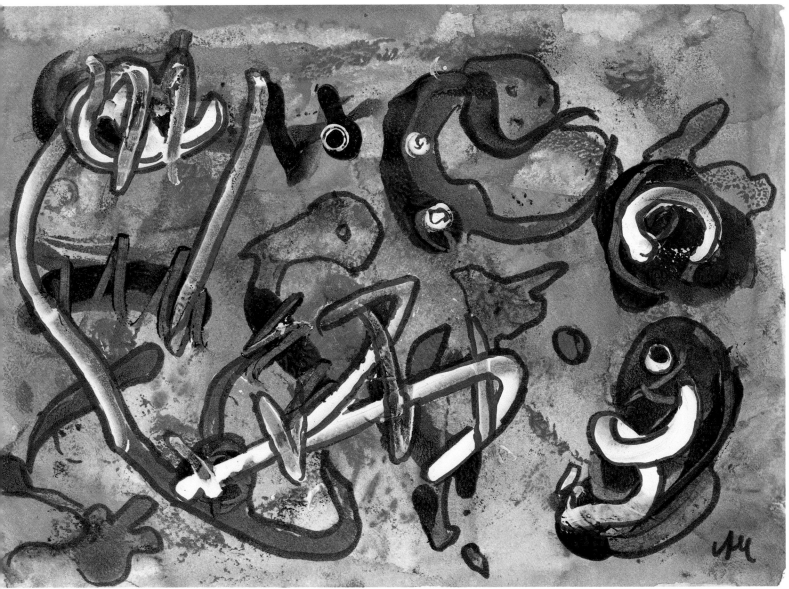

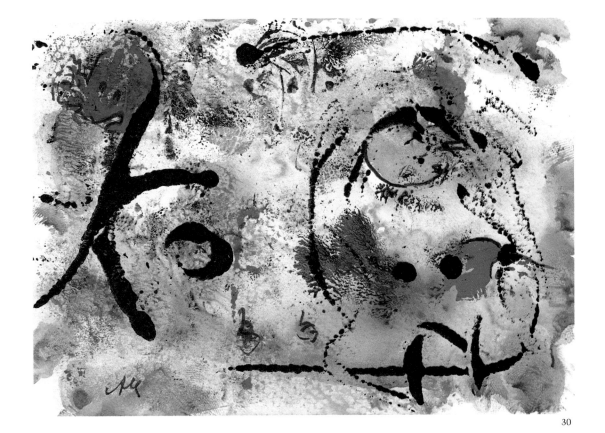

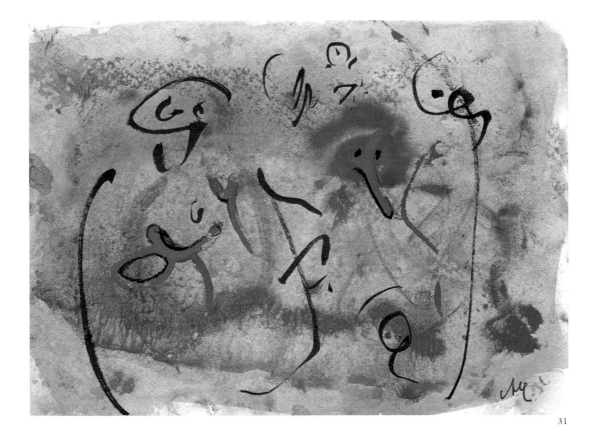

31

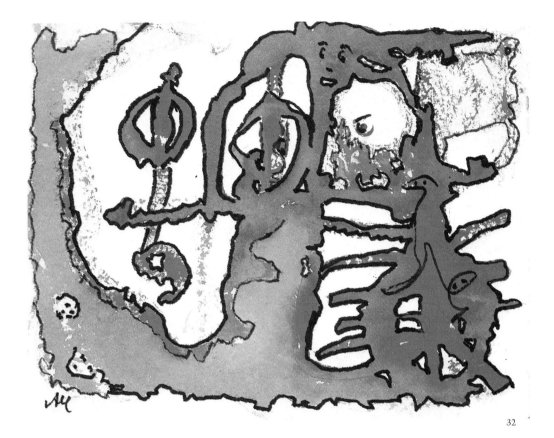

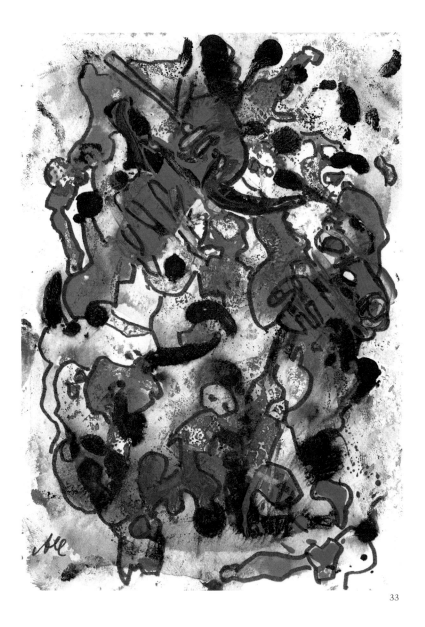

33

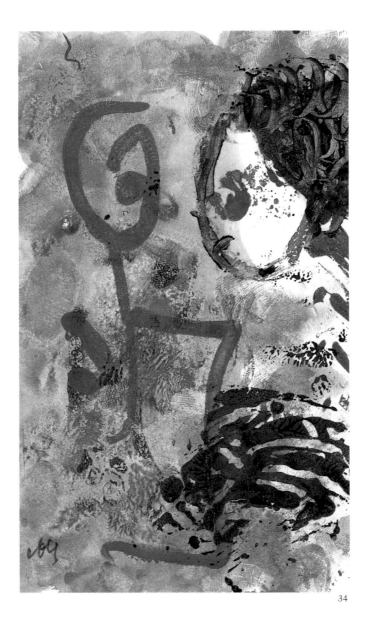

34

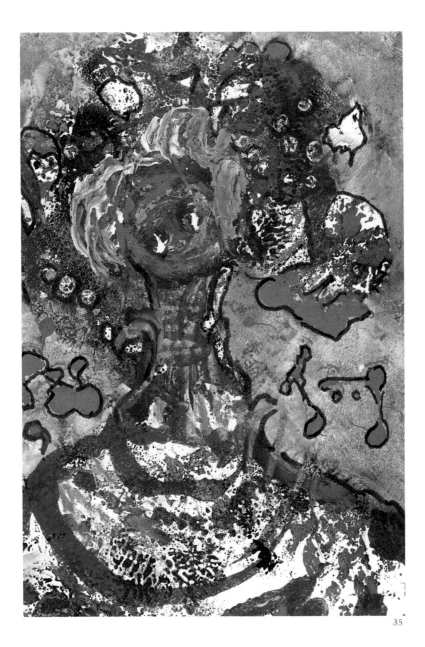

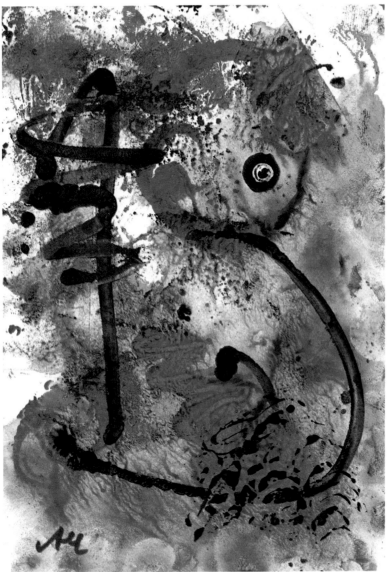

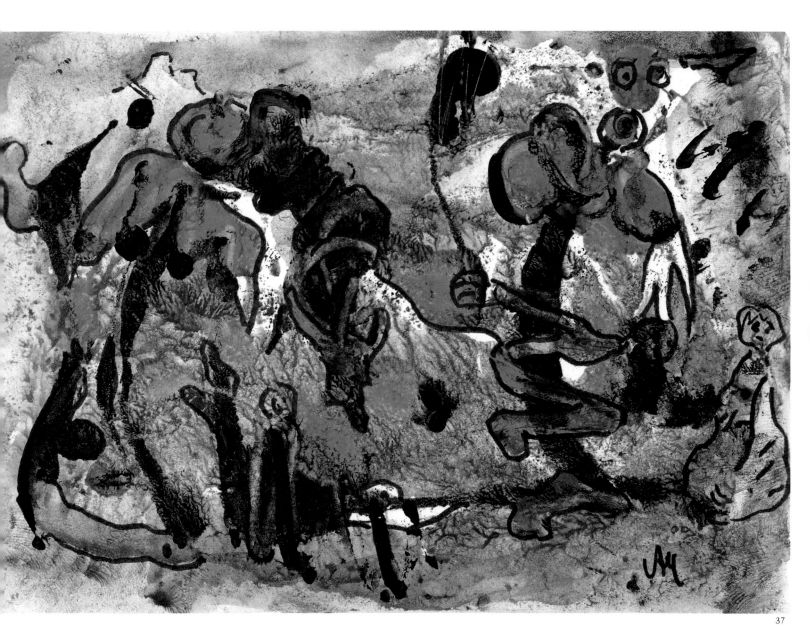

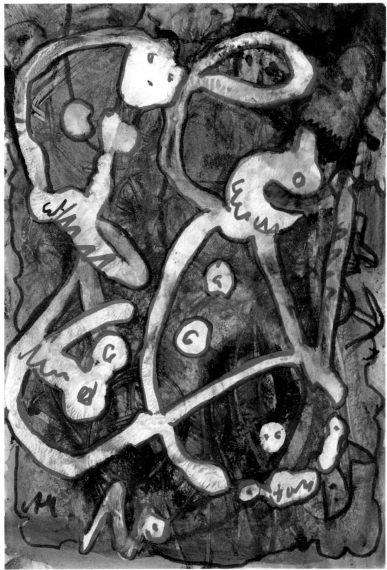

38

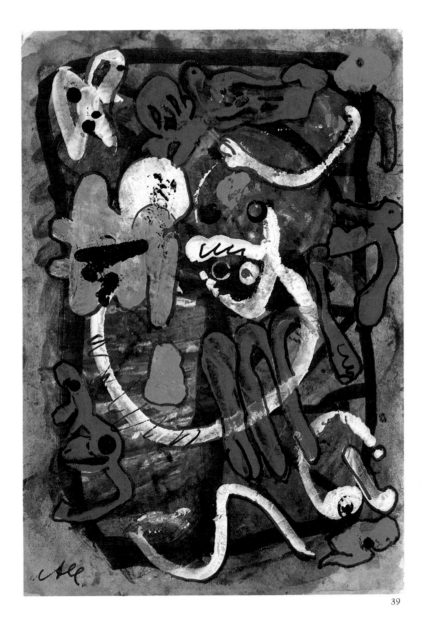

39

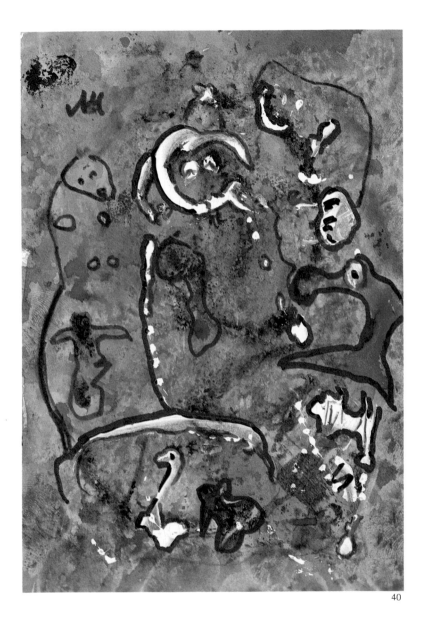

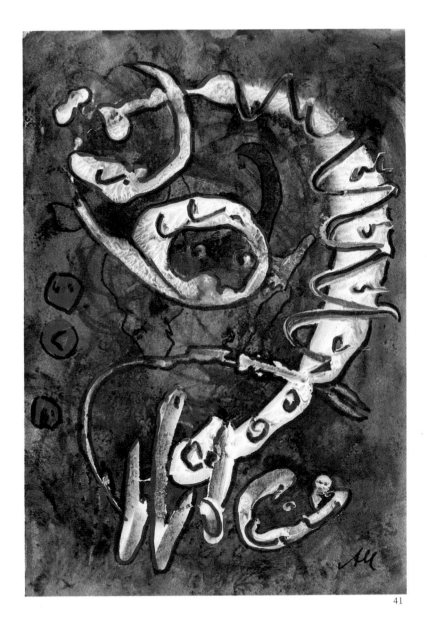

41

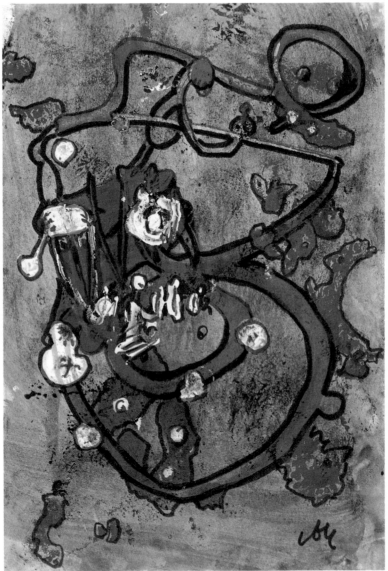

42

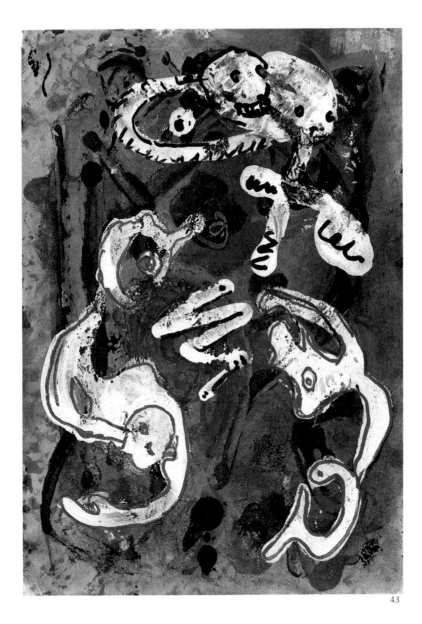

43

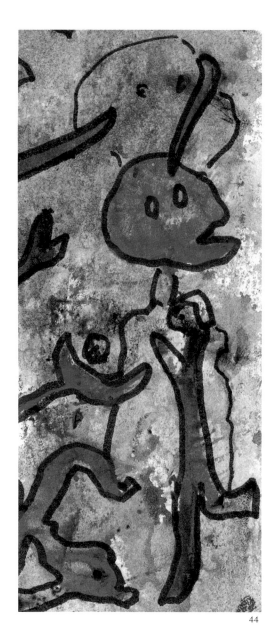

44

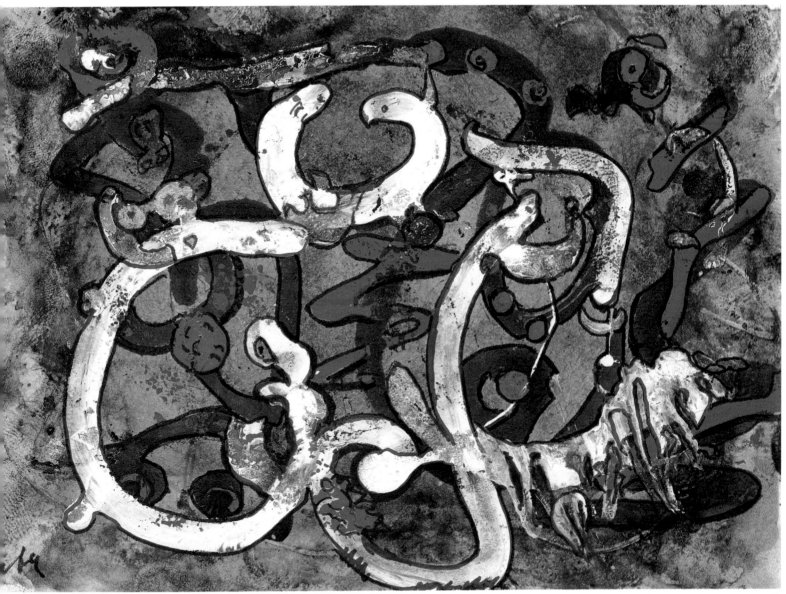

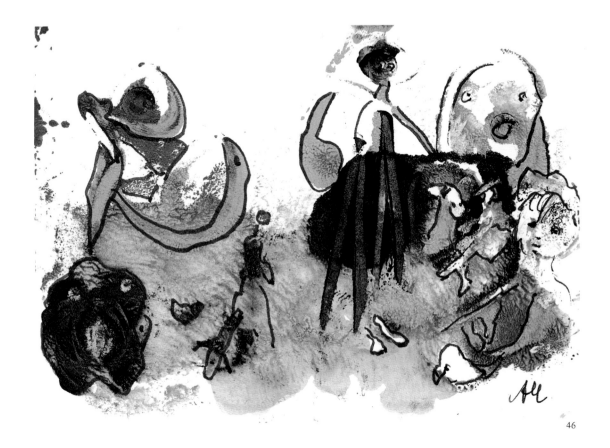

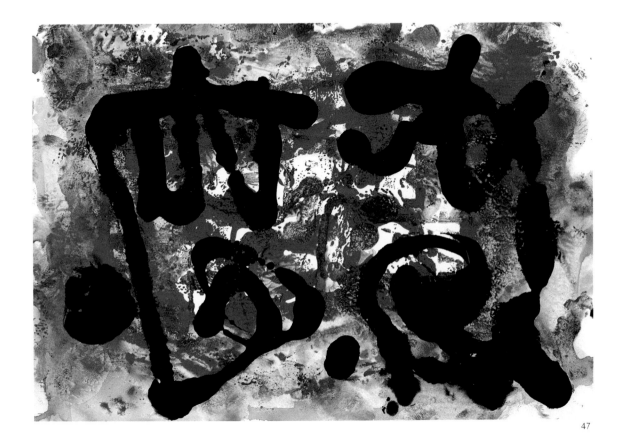

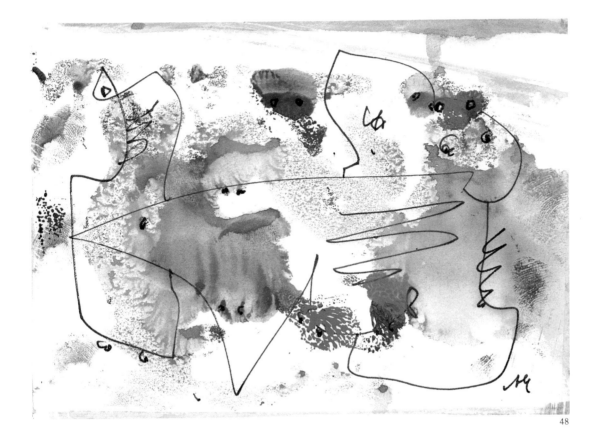

48

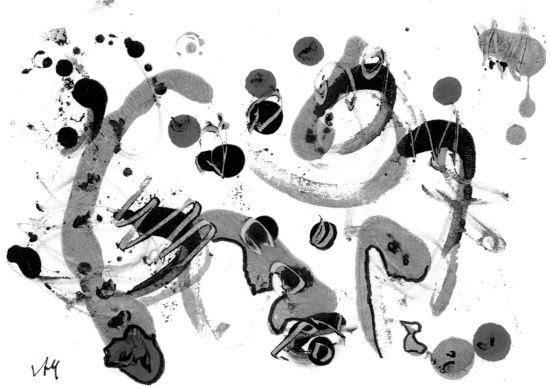

49

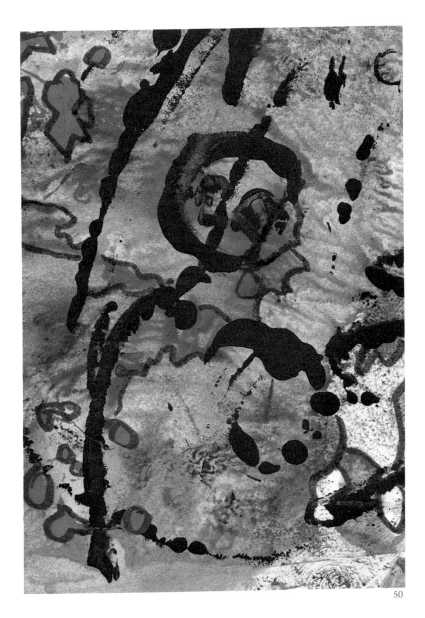

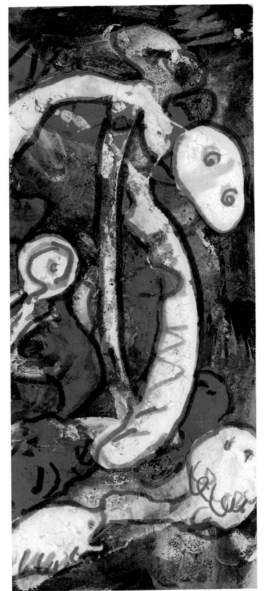

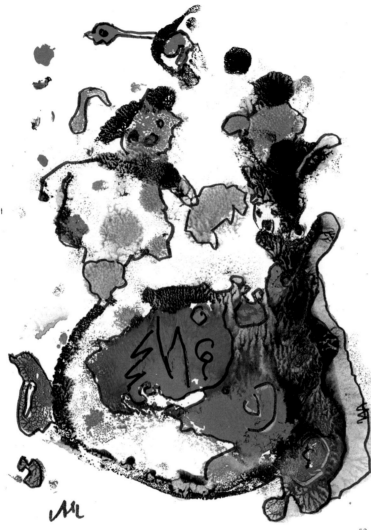

52

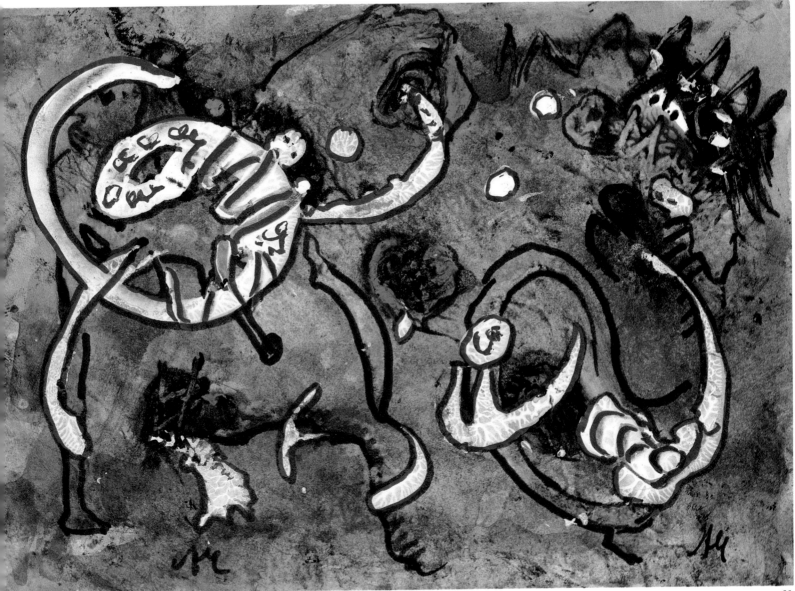

53

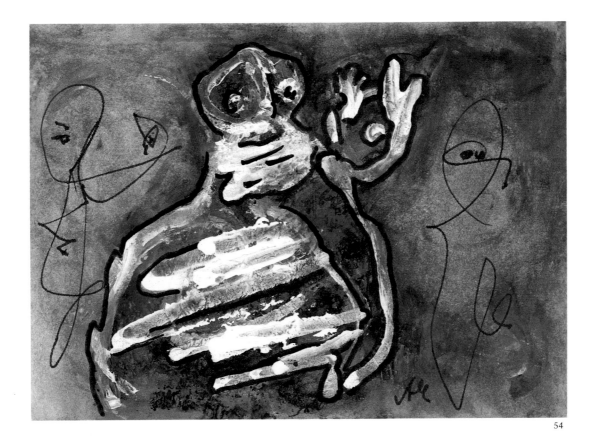

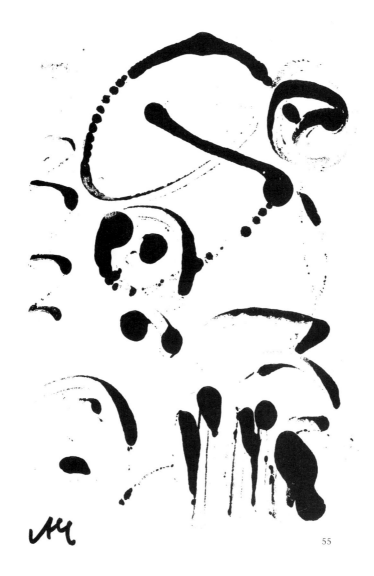

55

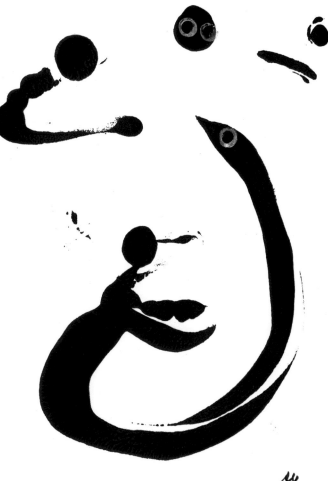

56

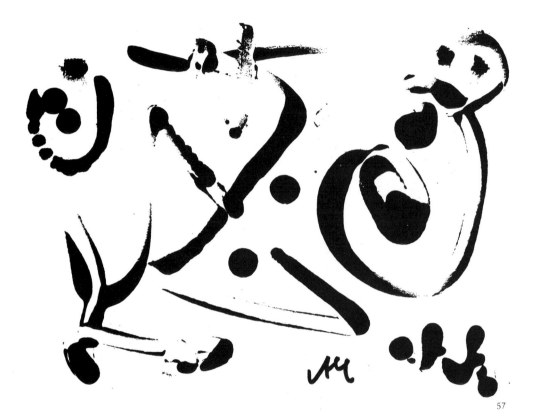

57

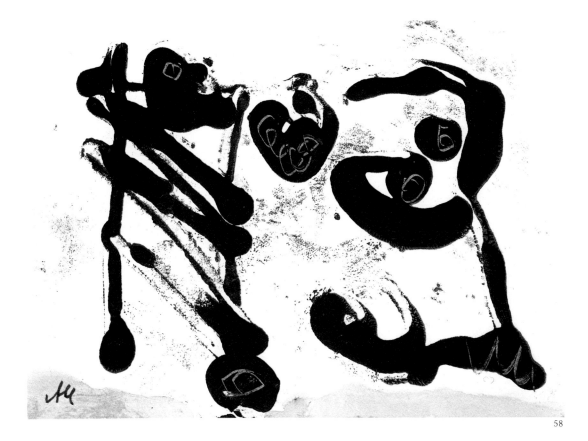

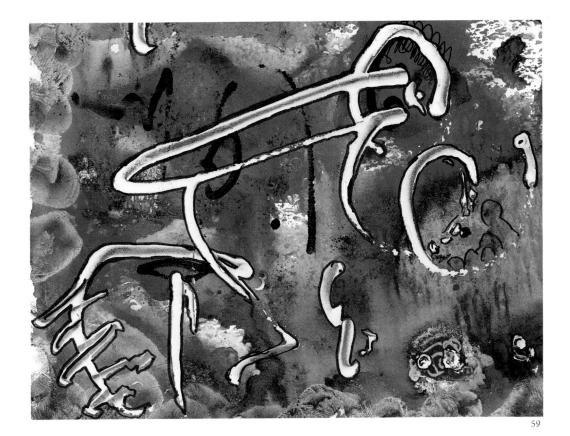

59

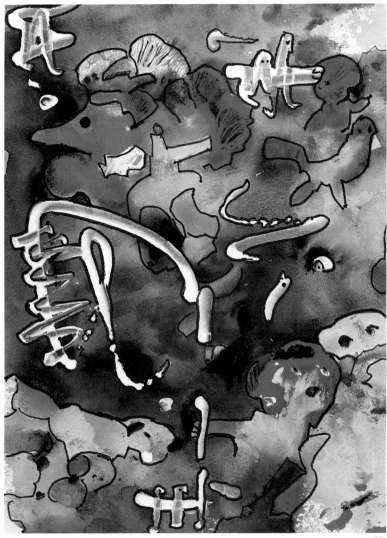

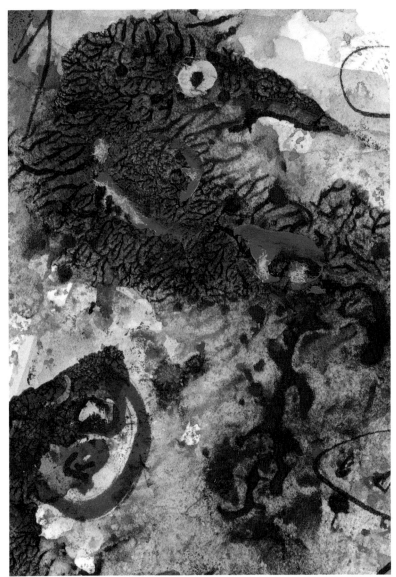

61

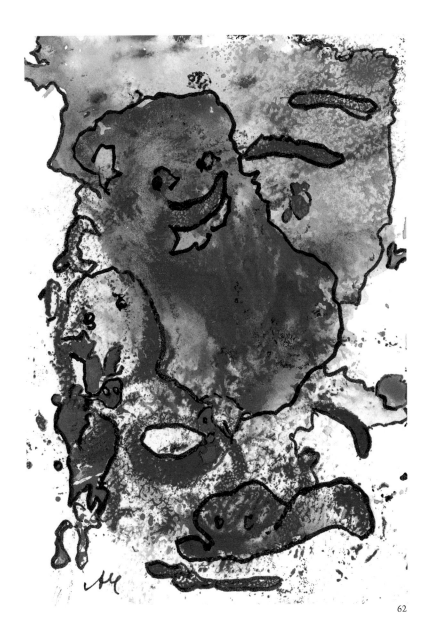

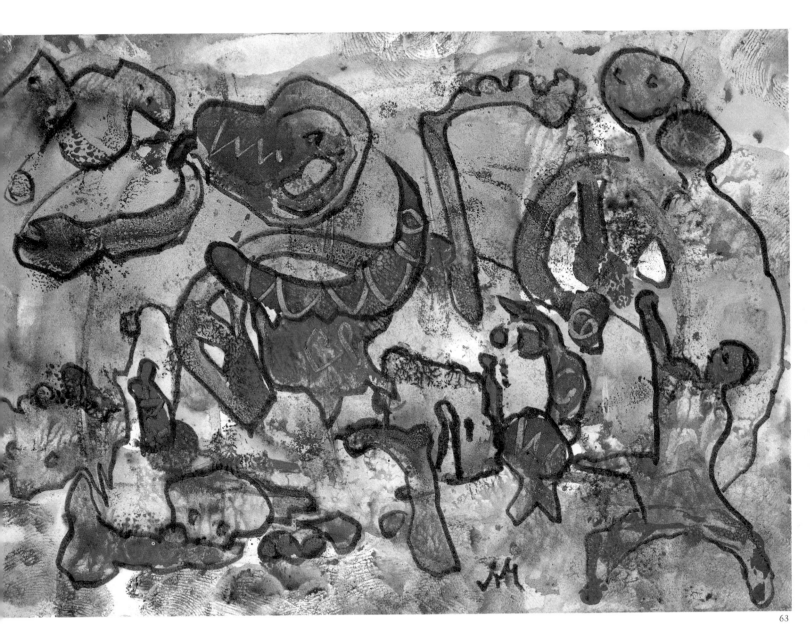

63

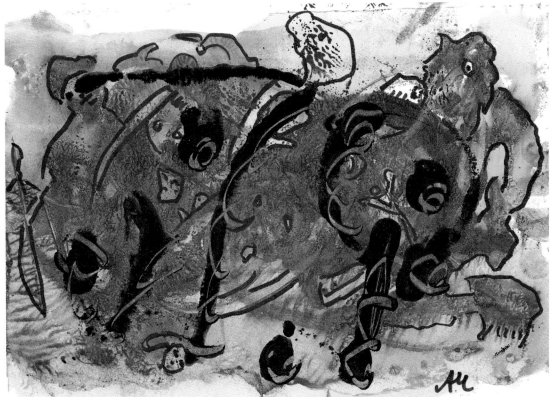

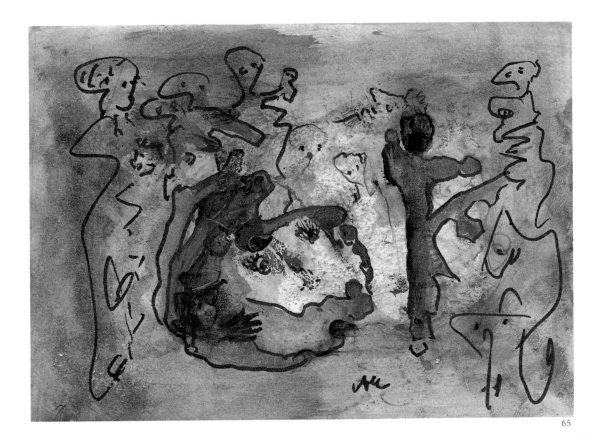

65

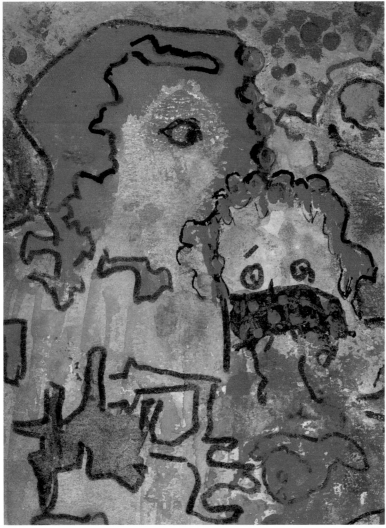

66

APPENDIX

This is an amended version of the Afterword to the second edition (1984) of *For Your Own Good*. I include it here because it may prove helpful to the reader who has not read my earlier books.

In 1613, when Galileo Galilei presented mathematical proof for the Copernican theory that the earth revolved around the sun and not the opposite, it was labeled "false and absurd" by the Church. Galileo was forced to recant and subsequently became blind. Not until three hundred years later did the Church finally decide to give up its illusion and remove his writings from the Index.

Now we find ourselves in a situation similar to that of the Church in Galileo's time, but for us today much more hangs in the balance. Whether we decide for truth or for illusion will have far more serious consequences for the survival of humanity than was the case in the seventeenth century. For some years now, there has been evidence that the devastating effects of the traumatization of children take their inevitable toll on society, leading to inconceivable violence in society and to the repetition of child abuse in the next generation—a phenomenon that we are still forbidden to recognize. This knowledge concerns every single one of us and—if disseminated widely enough—should lead to fundamental changes in society, above all to a halt in the blind escalation of violence. The following points are intended to amplify my meaning:

1. All children are born to grow, to develop, to live, to love, and to articulate their needs and feelings for their self-protection.
2. For their development, children need the respect and protection of adults who take them seriously, love them, and honestly help them to become oriented in the world.
3. When these vital needs are frustrated and children are, instead, abused for the sake of adults' needs by being exploited, beaten, punished, taken advantage of, manipulated, neglected, or deceived without the intervention of any witness, then their integrity will be lastingly impaired.

4. The normal reactions to such injury should be anger and pain. Since children in this hurtful kind of environment are forbidden to express their anger, however, and since it would be unbearable to experience their pain all alone, they are compelled to suppress their feelings, repress all memory of the trauma, and idealize those guilty of the abuse. Later they will have no memory of what was done to them.

5. Dissociated from the original cause, their feelings of anger, helplessness, despair, longing, anxiety, and pain will find expression in destructive acts against others (criminal behavior, mass murder) or against themselves (drug addiction, alcoholism, prostitution, psychic disorders, suicide).

6. If these people become parents, they will then often direct acts of revenge for their mistreatment in childhood against their own children, whom they use as scapegoats. Child abuse is still sanctioned—indeed, held in high regard—in our society as long as it is defined as child-rearing. It is a tragic fact that parents beat their children in order to escape the emotions stemming from how they were treated by their own parents.

7. If mistreated children are not to become criminals or mentally ill, it is essential that at least once in their life they come in contact with a person who knows without any doubt that the environment—not the helpless, battered child—is at fault. In this regard, knowledge or ignorance on the part of society can be instrumental in either saving or destroying a life. Here lies a great opportunity for relatives, social workers, therapists, doctors, psychiatrists, nurses, and officials to believe and support the child.

8. Till now, society has protected the adult and blamed the victim. It has been abetted in its blindness by theories, still in keeping with the pedagogical principles of our great-grandparents, according to which children are viewed as crafty creatures, dominated by wicked drives, who invent stories and attack their innocent parents or desire them sexually. In reality, children tend to blame themselves for their parents' cruelty and to absolve the parents, whom they invariably love, of all responsibility.

9. For some years now, it has been possible to prove, thanks to new therapeutic methods, that the repressed traumatic experiences of childhood are stored up in the body and, though remaining

160

unconscious, exert their influence in adulthood. In addition, electronic testing of the fetus has revealed a fact previously unknown to most adults—that *a child responds to and learns both tenderness and cruelty from the very beginning.*

10. In the light of this new knowledge, even the most absurd behavior reveals its formerly hidden logic once the traumatic experiences of childhood need no longer remain shrouded in darkness.

11. Our sensitization to the cruelty with which children are treated, until now commonly denied, and to the consequences of such treatment will, as a matter of course, bring to an end the perpetuation of violence from generation to generation.

12. People whose integrity has not been damaged in childhood, who were protected, respected, and treated with honesty by their parents, will be—both in their youth and in adulthood—intelligent, responsive, empathic, and sensitive. They will take pleasure in life and will not feel any need to kill or even hurt others or themselves. They will use their power to defend themselves, not to attack others. They will not be able to do otherwise than respect and protect those weaker than themselves, including their children, because this is what they have learned from their own experience and because it is *this* knowledge (and not the experience of cruelty) that has been stored up inside them from the beginning. It will be inconceivable to such people that earlier generations had to build up a gigantic war industry in order to feel comfortable and safe in this world. Since it will not be their unconscious task in life to ward off intimidation experienced at a very early age, they will be able to deal with attempts at intimidation in their adult life more rationally and more creatively.